weap

the pocket

Yishan Li

weapons & vehicles

the pocket reference to drawing manga

Yishan Li

Search Press

First published in Great Britain 2011 by
Search Press Limited
Wellwood, North Farm Road,
Tunbridge Wells, Kent TN2 3DR

Created and conceived by
Axis Publishing Limited
8c Accommodation Road
London NW11 8ED
www.axispublishing.co.uk

Creative Director: Siân Keogh
Editor:Anna Southgate
Designer: Simon de Lotz
Production: Bili Books

ISBN: 978-1-84448-545-1

contents

Introduction

Originating in Japan, manga art has become popular across the globe. Taking its name from the Japanese word for 'comic', much of its popularity is down to the traditional content of the comic-strip stories. Invariably they involve a moralistic tale of good versus evil, in which good inevitably claims victory. Along the way, characters face challenges and encounter strange beings that look set to obstruct their goals. What is unique about the form is the element of rebellion in the way that characters are portrayed: hideous-looking monsters turn out to be innocent, weak and friendly, while an attractive, sporty young girl might be

a devious, dangerous foe. Many
of the stories involve trickery and
duplicity as complex characters
use special powers, weapons and
strategies to pitch their wits against
one another.

weapons and vehicles

Alongside the 'human' looking
characters in these manga stories
are all manner of accessories in the

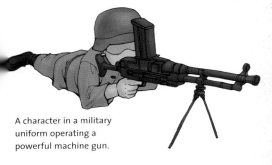

A character in a military
uniform operating a
powerful machine gun.

form of weapons and vehicles. In order to draw them, you will need some very basic art materials (see pages 12–19) but a vivid imagination is just as important, and that is where this book comes in.

Step by step, the instructions on the following pages show you how to draw 25 weapons and 27 vehicles – from the very first rough sketch to finished artwork. You will learn how to draw each one accurately, making sure you get proportion and perspective right. Each project guides you through the drawing process and encourages you to think carefully about the kinds of materials used – metals, wood, plastics.

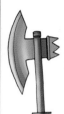

inspiration

When it comes to inspiration for your weapons and vehicles, there are countless examples to choose from.

You can use real photographs or illustrations of actual weapons – an ancient Asian sword, a medieval flail or a state-of-the art machine gun. Or you can base your vehicles on actual models – a modern-day people carrier, a luxury passenger ship or a trendy scooter.

You can also use any of the projects in the book to develop designs of your own, mixing and matching features to suit a particular story line. The only limit is your vision.

Perspective is key when drawing vehicles from a three-quarter view.

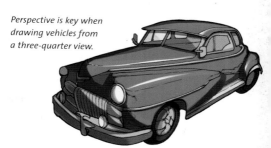

equipment

In order to create your own
manga art, it is a good idea to
invest in a range of materials
and equipment. The basics
include paper for sketches
and finished artworks, pencils
and inking pens for drawing,
and colour pencils, markers or
paints for finishing off. There
are also a handful of drawing
aids that will help produce
more professional results.

drawing

Every manga drawing must start with a pencil sketch –
this is essential. You need to build each subject
gradually, starting with a structural guide and adding
body shape, then details, in layers. The best way to do
this effectively is by using a pencil.

pencils

You can use a traditional graphite pencil or a mechanical
one according to preference. The advantages of the latter
are that it comes in different widths and does not need
sharpening. Both sorts are available in a range of hard
leads (1H to 6H) or soft leads (1B to 6B); the higher the
number in each case, the harder or softer the pencil. An
HB pencil is halfway between the two ranges and will give
you accurate hand-drawn lines. For freer, looser sketches,
opt for something softer – say a 2B lead.

Some of the sketches in this book are drawn using a blue
lead. This is particularly useful if you intend to produce
your artworks digitally, as blue does not show up when
photocopied or scanned. If you opt for a traditional
graphite pencil, you will also need a pencil sharpener.

*An eraser or putty eraser is
an essential tool. Use it to
remove and correct
unwanted lines or to white-
out those areas that need
highlights. Choose a good-
quality eraser that will not
smudge your work.*

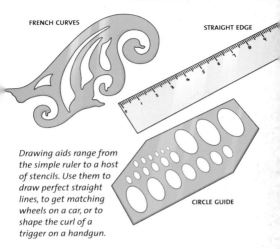

FRENCH CURVES

STRAIGHT EDGE

CIRCLE GUIDE

Drawing aids range from the simple ruler to a host of stencils. Use them to draw perfect straight lines, to get matching wheels on a car, or to shape the curl of a trigger on a handgun.

drawing aids and guides

The tips in this book show you how to draw convincing manga characters from scratch by hand. There may be times, however, when drawing by hand proves a little too difficult. Say your composition features a futuristic city scape; you might want to use a ruler to render the straight edges of the buildings more accurately. The same could be true if you wanted to draw more precise geometric shapes – a true circle for the sun, for example.

inking and colouring

Once you have finished your manga drawing in pencil, you can start to add colour. This is where you can really let your imagination run free. There are numerous art materials available for inking and colouring, and it pays to find out which ones suit you best.

inking

A good manga drawing relies on having a crisp, clean, solid black outline, and the best way to achieve this is by using ink. You have two choices here. First is the more traditional technique, using pen and ink. This involves a nib with an ink cartridge, which you mount in a pen holder. The benefit of using this method is that you can vary the thickness of the strokes you draw, depending on how much pressure you apply as you work. You also tend to get a high-quality ink. The alternative to using pen and ink is the felt-tipped drawing pen, which comes in a range of widths. A thin-nibbed pen (0.5mm) is best, but it is also a good idea to have a medium-nibbed pen (0.8mm) for more solid blocks of ink. Whichever option you go for, make sure the ink is quick-drying and/or waterproof so that it does not run or smudge as you work.

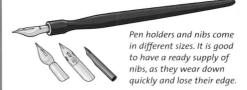

Pen holders and nibs come in different sizes. It is good to have a ready supply of nibs, as they wear down quickly and lose their edge.

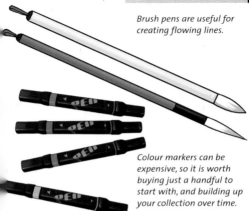

Brush pens are useful for creating flowing lines.

Colour markers can be expensive, so it is worth buying just a handful to start with, and building up your collection over time.

colouring

There are various options available to you when it comes to colouring your work. The most popular method is to use marker pens. These are fast-drying and available in very many colours. You can use them to build up layers of colour, which really helps when it comes to creating shading in, say, bright metals. You can also use colour pencils and paints very effectively (gouache or watercolour). Colour pencils and watercolours are probably the most effective media for building up areas of tone – say for skin – and also for blending colours here and there. White gouache is very useful for creating highlights, and is best applied with a brush.

papers

It is difficult to imagine that you will have the perfect idea for a weapon or vehicle every time you want to draw a manga scenario. These need to be worked at in terms of the era from which they come and their appearance. It is a good idea, therefore, to have a sketchbook to hand so that you can try out different ideas. Tracing paper is best for this, as its smooth surface allows you to sketch more freely. You can also erase unwanted lines several times over without tearing the paper. A recommended weight for tracing paper is 90gsm.

Having sketched out a few ideas you will want to start on a proper composition, where you move from pencil outline to inked drawing to finished coloured art. If you are tracing over a sketch you have already made, it is best to use paper that is only slightly opaque, say 60gsm. In order to stop your colours bleeding as you work, it is important that you buy 'marker' or 'layout' paper. Both of these are good at holding colour without it running over your inked lines and blurring the edges. 'Drawing' paper is your best option if you are using just coloured pencils with the inked outline, while watercolour paper is, of course, ideal for painting with watercolour – a heavyweight paper will hold wet paint and colour marker well. You also have a choice of textures here.

It is always best to allow space around the edge of your composition, to make sure that the illustration will fill the frame.

20мм

TRIM

20мм

IMAGE AREA
(SAFETY ZONE)

20мм

TRIM

20мм

using a computer

The focus of this book is in learning how to draw and colour manga scenarios by hand. Gradually, by practising the steps over and again you will find that your sketches come easily and the more difficult features, such as texture and perspective begin to look more convincing. Once that happens, you will be confident enough to expand on the range of scenes you draw. You might even begin to compose cartoon strips of your own or, at the very least, draw compositions in which several characters interact with each other – such as a battle scene.

Once you reach this stage, you might find it useful to start using a computer alongside your regular art materials. Used with a software program, like Adobe Photoshop, you can colour scanned-in sketches quickly and easily. You will also have a much wider range of colours to use, and can experiment at will.

Any home computer can be used for colouring your manga sketches in order to produce finished art.

You can input a drawing straight into a computer program by using a graphics tablet and pen. The tablet plugs into your computer, much like a keyboard or mouse.

Moving one step further, a computer can save you a lot of time and energy when it comes to producing comic strips. Most software programs enable you to build a picture in layers. This means that you could have a general background layer – say a mountainous landscape – that always stays the same, plus a number of subsequent layers on which you can build your story. For example, you could use one layer for activity that takes place in the sky and another layer for activity that takes place on the ground. This means that you can create numerous frames simply by making changes to one layer, while leaving the others as they are. There is still a lot of work involved, but working this way does save you from having to draw the entire frame from scratch each time.

Of course, following this path means that you must invest in a computer if you don't already have one. You will also need a scanner and the relevant software. All of this can be expensive and it is worth getting your hand-drawn sketches up to a fairly accomplished level before investing too much money.

weapons

With 25 step-by-step projects in total, this sections shows you how to draw an entire arsenal of weapons – from the lethal axes and hammers used in ancient times to medieval swords and the latest state-of-the art missile launchers. There is instruction on how to capture the look of different materials, including wood, steel and gold.

weapon materials

Designed to maim or kill, weapons are highly functional objects, made from hard, durable materials.

Wood is often used for grips, handles and butts. It has a warm, non-slip texture. You can make it look realistic by capturing the grain of the wood in its surface. Wood rarely has bright highlights.

Steel is used for the majority of the weapons in this book. Hard and durable, it is ideal for swords and guns. It has a dull silver finish, so highlights should be bright, but well-blended.

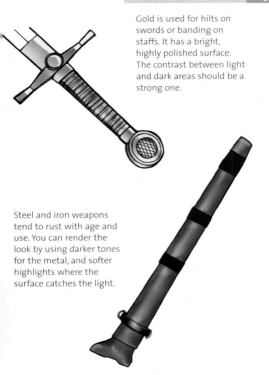

Gold is used for hilts on swords or banding on staffs. It has a bright, highly polished surface. The contrast between light and dark areas should be a strong one.

Steel and iron weapons tend to rust with age and use. You can render the look by using darker tones for the metal, and softer highlights where the surface catches the light.

traditional asian axe

This medieval weapon combines a spike for thrusting an opponent in battle with an axe for chopping.

2 Fine-tune your pencil drawing. Concentrate on getting the shape of the axe blade right. Draw in the tassels at the base of the axe head.

1 Begin by drawing a pencil sketch of the axe. These weapons were often taller than the men who used them. Consider proportions carefully.

4 Colour your weapon, paying close attention to materials. The gold axe head should have the bright sheen of metal, while the wood of the pole has no bright highlights.

3 Go over your drawing using ink and erase any unwanted pencil lines. Your artwork should be ready to colour now.

guan dao

This ancient Chinese weapon has a large, curved blade used for making sweeping attacks on an opponent.

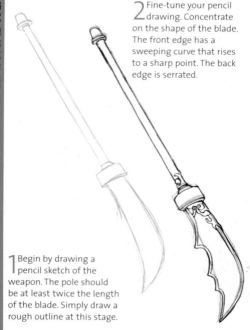

2 Fine-tune your pencil drawing. Concentrate on the shape of the blade. The front edge has a sweeping curve that rises to a sharp point. The back edge is serrated.

1 Begin by drawing a pencil sketch of the weapon. The pole should be at least twice the length of the blade. Simply draw a rough outline at this stage.

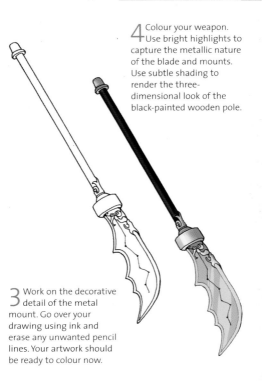

4 Colour your weapon. Use bright highlights to capture the metallic nature of the blade and mounts. Use subtle shading to render the three-dimensional look of the black-painted wooden pole.

3 Work on the decorative detail of the metal mount. Go over your drawing using ink and erase any unwanted pencil lines. Your artwork should be ready to colour now.

kanabo

This brutal weapon has its origins in feudal Japan, where it was used to smash through the armour of an opponent.

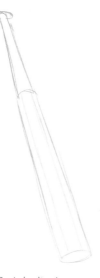

2 Give more shape to the club. This example is faceted and tapers towards the grip end. The head is pierced with metal studs.

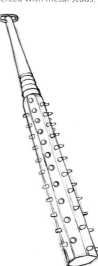

1 Begin by drawing a pencil sketch of the weapon – in this instance a basic club shape.

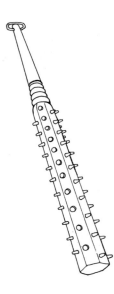

4 Colour your weapon. The club head is made from wood. Use subtle shading with no highlights. The grip end is made from iron – a dull metal with soft highlights.

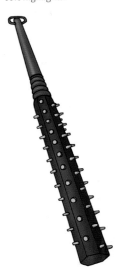

3 Go over your drawing using ink and erase any unwanted pencil lines. Your artwork should be ready to colour now.

meteor hammer

A number of weights attached to rope or chain, the ancient Chinese meteor hammer is both swift and flexible.

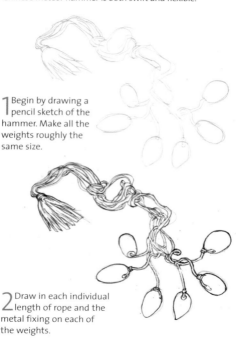

1 Begin by drawing a pencil sketch of the hammer. Make all the weights roughly the same size.

2 Draw in each individual length of rope and the metal fixing on each of the weights.

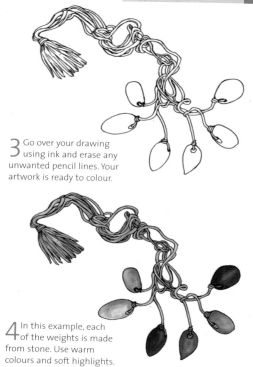

3 Go over your drawing using ink and erase any unwanted pencil lines. Your artwork is ready to colour.

4 In this example, each of the weights is made from stone. Use warm colours and soft highlights.

nunchaku

This weapon has its origins in ancient China and consists of two lengths of wood connected at one end using chain.

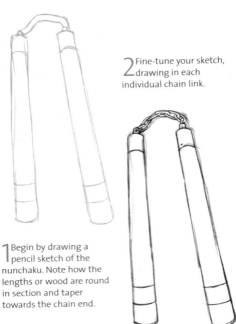

2 Fine-tune your sketch, drawing in each individual chain link.

1 Begin by drawing a pencil sketch of the nunchaku. Note how the lengths or wood are round in section and taper towards the chain end.

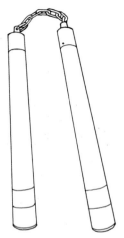

4 Use sharp highlights to capture the curved surfaces of the metal elements. The smooth, light-coloured wood is highly polished and so has bright highlights.

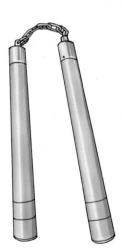

3 Go over your drawing using ink and erase any unwanted pencil lines. Your artwork is ready to colour.

chinese dao

The traditional dao – a weapon used for cutting and thrusting – originates in ancient China.

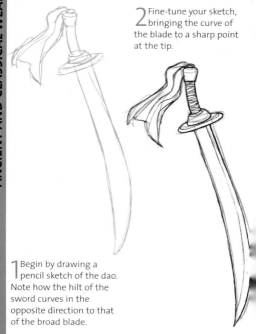

2 Fine-tune your sketch, bringing the curve of the blade to a sharp point at the tip.

1 Begin by drawing a pencil sketch of the dao. Note how the hilt of the sword curves in the opposite direction to that of the broad blade.

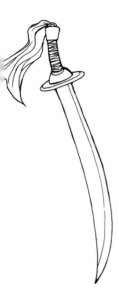

4 The sword is made from a silver metal. Use high-contrast shading to capture its sheen. Use strong colours for the cord grip and scarf tie.

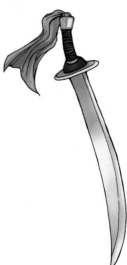

3 Go over your drawing using ink and erase any unwanted pencil lines. Your artwork is ready to colour.

gladius sword

This ancient Roman sword is an effective stabbing weapon. It has a double-edged, tapered blade.

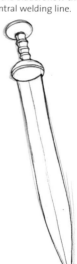

2 Fine-tune your sketch. Draw the hilt in greater detail and give more shape to the blade. Show the central welding line.

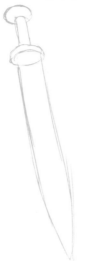

1 Begin by drawing a pencil sketch of the sword. Note how the hilt is shaped for the fingers to grip firmly.

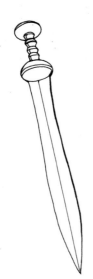

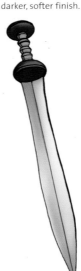

4 The sword is a diamond shape in cross-section. Use bright highlights to show the angled metal surfaces. The iron hilt has a darker, softer finish.

3 Go over your drawing using ink and erase any unwanted pencil lines. Your artwork is ready to colour.

jian sword

A strong, sturdy sword from ancient China. Originally made from bronze, this example uses steel.

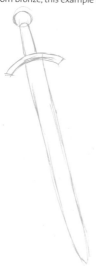

2 Fine-tune your sketch. The tapering, double-edged blade has a visible ridge down its centre.

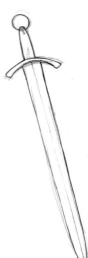

1 Begin by drawing a pencil sketch of the sword. This example has a round pommel at the end of the hilt.

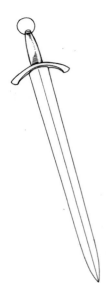

4 The sword is a diamond shape in cross-section. Use highlights to show the angled metal surfaces. Keep highlights on the wood to a minimum.

3 Go over your drawing using ink and erase any unwanted pencil lines. Add any additional ink shading – on the hilt, for example.

wakizashi sword

A traditional sword, with origins in medieval Japan. It is a short version of the samurai sword.

2 Fine-tune your sketch. The blade is long and narrow, tapering very slightly to a sharp point.

1 Begin by drawing a pencil sketch of the sword. This example has a square-section guard between the blade and the hilt.

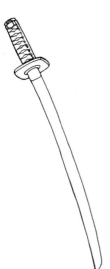

4 Use bright highlights to show how the metal blade catches the light. The hilt is encased in a leather binding. Use soft tones here, with no highlights.

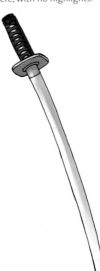

3 Go over your drawing using ink and erase any unwanted pencil lines. Your artwork should be ready to colour now.

kris sword

The asymmetrical kris sword was used in ancient times in countries across the whole of Southeast Asia.

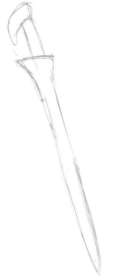

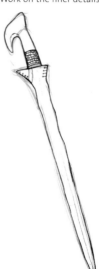

2 Fine-tune your sketch. The blade is long and slightly wavy in design. Work on the finer details.

1 Begin by drawing a pencil sketch of the sword. It has a distinctive grip and tapers to a point.

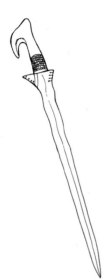

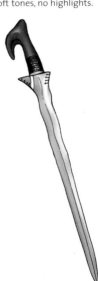

4 Use bright highlights to show how the metal blade catches the light. The grip is made of wood. Use soft tones, no highlights.

3 Go over your drawing using ink and erase any unwanted pencil lines. Your artwork should be ready to colour now.

katara sword

This medieval Indian sword is held in such a way that the blade of the knife projects from the knuckles.

2 Fine-tune your sketch. The blade is broad and bevelled. Begin to add the decorative details.

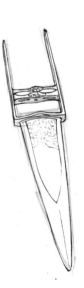

1 Begin by drawing a pencil sketch of the sword. It has a short grip, shaped like the letter H.

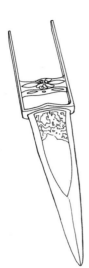

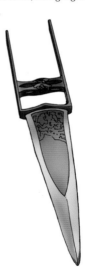

4 Use bright highlights to show how the bright metal blade catches the light. The metal of the grip has a dullness to it. Use soft tones, no highlights.

3 Complete any decoration on the hilt and blade. Go over your drawing in ink and erase unwanted pencil lines.

yatagan sword

A medieval Turkish sword, the yatagan has a single-edge, forward-curving blade.

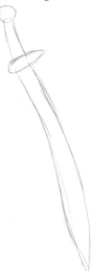

2 Fine-tune your sketch. The blade is broad and sculptural. Give more shape to the hilt.

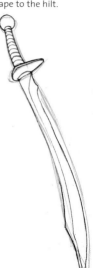

1 Begin by drawing a pencil sketch of the sword. It has a short hilt with a pommel.

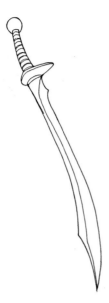

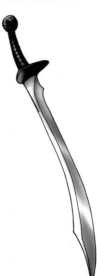

4 Use bright highlights to show how the bright steel of the blade catches the light. Use darker, softer tones for the iron hilt.

3 Go over your drawing in ink and erase unwanted pencil lines. Your drawing is ready to colour now.

longsword

Designed to be held in both hands, the longsword originates in medieval Europe.

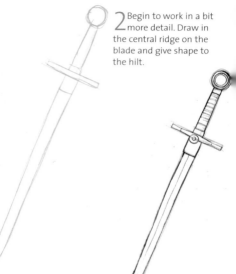

2 Begin to work in a bit more detail. Draw in the central ridge on the blade and give shape to the hilt.

1 Begin by drawing a pencil sketch of the sword. This example has a long, tapering blade and a cruciform hilt.

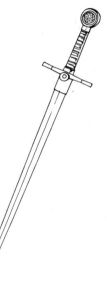

4 Colour the sword, using bright highlights to render the metallic finish of the steel blade and the gold elements of the hilt. Use flat colour for the cloth binding on the grip.

3 Add any decorative details. Go over your drawing in ink and erase unwanted pencil lines.

dress sword

Popular in Europe during the late-18th and early-19th centuries, this is a light, one-handed weapon.

2 Begin to work in a bit more detail. Give more shape to the narrow blade and fine-tune the design of the hilt.

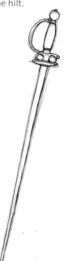

1 Begin by drawing a pencil sketch of the sword. This example has a long, slim tapering blade.

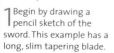

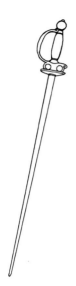

4 Keep the colouring simple. The entire sword is made from steel, with just the grip covered in cloth. Use subtle tones to capture the metal finish.

3 Go over your drawing in ink and erase unwanted pencil lines. Your work is ready for colour now.

Asian spear

This Asian spear has a small, sharp-pointed, diamond-shaped steel blade.

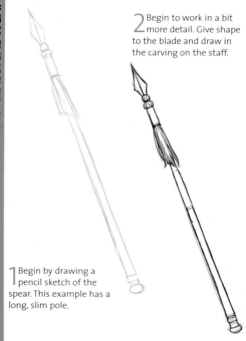

2 Begin to work in a bit more detail. Give shape to the blade and draw in the carving on the staff.

1 Begin by drawing a pencil sketch of the spear. This example has a long, slim pole.

4 Colour your work. The staff is made from black-painted wood. Use subtle soft highlights where the carved elements catch the light.

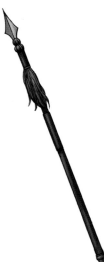

3 Build on the tassels. Go over your drawing in ink and erase unwanted pencil lines.

bow and arrow

The bow and arrow was a popular choice of weapon in Europe and Asia during the Middle Ages.

1 Begin by drawing a pencil sketch of the bow and arrow. Note the slender curves of the bow and the small head of the arrow.

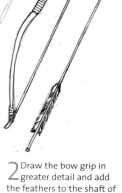

2 Draw the bow grip in greater detail and add the feathers to the shaft of the arrow.

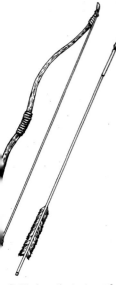

4 Colour your work. Both the bow and the shaft of the arrow are made from wood. Use soft, warm browns here. Emphasise the metal of the arrow tip with a couple highlights.

3 Work on the texture of the wood, drawing in details of the grain. Go over your drawing in ink and erase any unwanted pencil lines.

crossbow

The crossbow was a weapon of choice during medieval European and Asian warfare.

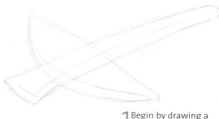

1 Begin by drawing a pencil sketch of the stock – essentially a solid, wooden structure.

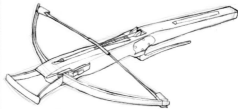

2 Draw the stock in greater detail, complete with firing mechanism, trigger and bow string.

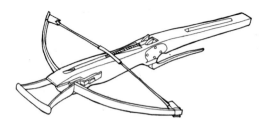

3 Go over your drawing in ink and erase any unwanted pencil lines.

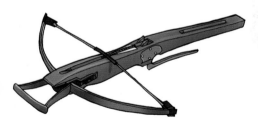

4 Colour your work. The structure is mostly made from wood, with metal elements for the bow and trigger.

hira-shuriken

This is a hand-held blade from medieval Japan, used for throwing and stabbing.

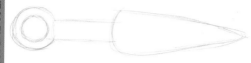

1 Begin by drawing a pencil sketch of the weapon. It has a simple shape with the blade taking half its length.

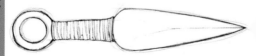

2 Draw the knife in greater detail. Give shape to the blade and draw in the texture of the cloth-bound grip.

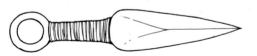

3 Go over your drawing in ink and erase any unwanted pencil lines. Your work is ready for colouring.

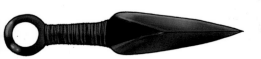

4 Use a strong colour to capture the tough steel blade, adding highlights where the metal catches the light. Use softer tones for the cloth grip.

GALLERY

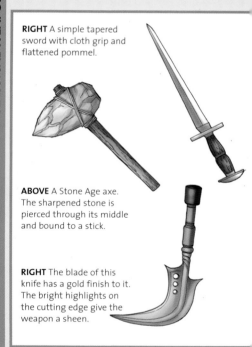

RIGHT A simple tapered sword with cloth grip and flattened pommel.

ABOVE A Stone Age axe. The sharpened stone is pierced through its middle and bound to a stick.

RIGHT The blade of this knife has a gold finish to it. The bright highlights on the cutting edge give the weapon a sheen.

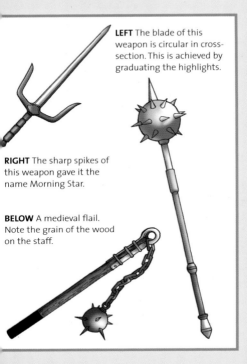

LEFT The blade of this weapon is circular in cross-section. This is achieved by graduating the highlights.

RIGHT The sharp spikes of this weapon gave it the name Morning Star.

BELOW A medieval flail. Note the grain of the wood on the staff.

browning pistol

This type of pistol was used by both the Axis forces and the Allies during the Second World War.

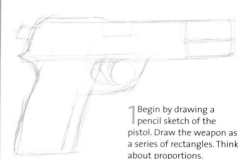

1 Begin by drawing a pencil sketch of the pistol. Draw the weapon as a series of rectangles. Think about proportions.

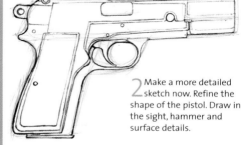

2 Make a more detailed sketch now. Refine the shape of the pistol. Draw in the sight, hammer and surface details.

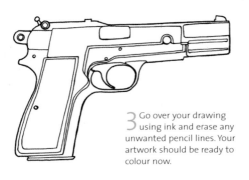

3 Go over your drawing using ink and erase any unwanted pencil lines. Your artwork should be ready to colour now.

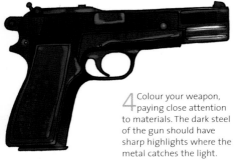

4 Colour your weapon, paying close attention to materials. The dark steel of the gun should have sharp highlights where the metal catches the light.

colt python revolver

Considered one of the finest revolvers ever made, the Colt Python originated in the US in the 1950s.

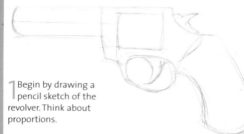

1 Begin by drawing a pencil sketch of the revolver. Think about proportions.

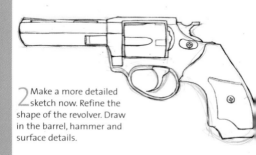

2 Make a more detailed sketch now. Refine the shape of the revolver. Draw in the barrel, hammer and surface details.

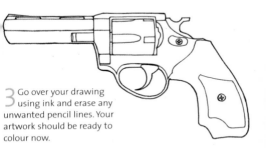

3 Go over your drawing using ink and erase any unwanted pencil lines. Your artwork should be ready to colour now.

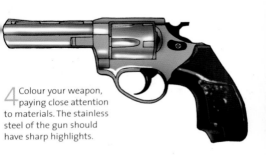

4 Colour your weapon, paying close attention to materials. The stainless steel of the gun should have sharp highlights.

AK47 assault rifle

This weapon is popularly known as the Kalashnikov rifle, after its Russian designer. It dates from the 1940s.

1 Begin by drawing a pencil sketch of the rifle. Think about proportions when drawing the various elements – barrel, butt, hand guard.

2 Make a more detailed sketch now. Refine the shape of the rifle. Draw in the details of the firing mechanism.

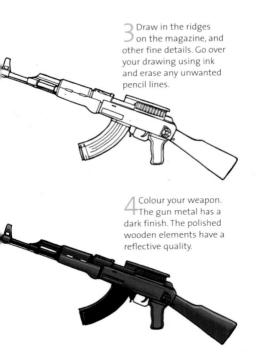

3 Draw in the ridges on the magazine, and other fine details. Go over your drawing using ink and erase any unwanted pencil lines.

4 Colour your weapon. The gun metal has a dark finish. The polished wooden elements have a reflective quality.

M40 sniper rifle

This bolt-action sniper rifle was first used by the US Marine Corps during the Vietnam War in the late 1960s.

1 Begin by drawing a pencil sketch of the rifle. Keep the outline slender and simple.

2 Refine your sketch, concentrating on the different sections – stock, barrel and so on. Give shape to the telescopic sight and trigger guard.

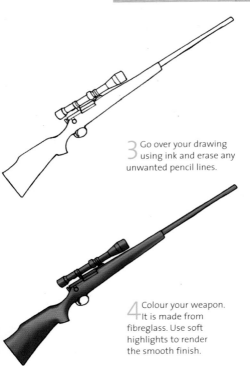

3 Go over your drawing using ink and erase any unwanted pencil lines.

4 Colour your weapon. It is made from fibreglass. Use soft highlights to render the smooth finish.

browning machine gun M2H

This powerful machine gun was first used towards the end of the First World War. It is still in use by the US today.

1 Begin by drawing a pencil sketch of the weapon. This example is mounted on a tripod. Keep your shapes simple.

2 Refine your sketch, concentrating on the proportions of the different sections. Draw in details such as the belt-feed and firing mechanism.

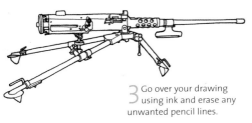

3 Go over your drawing using ink and erase any unwanted pencil lines.

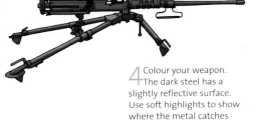

4 Colour your weapon. The dark steel has a slightly reflective surface. Use soft highlights to show where the metal catches the light.

howitzer cannon

This piece of artillery was designed in the United States towards the end of the 1970s.

1 Begin by drawing a pencil sketch of the cannon. Try to get the perspective right.

2 Refine your sketch. This is a complex design. You need to think about the various functions of the cannon, and how these change when in use.

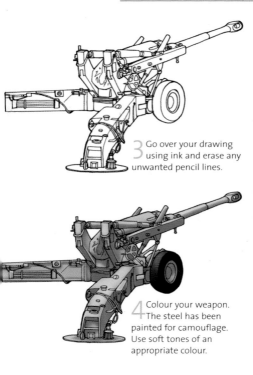

3 Go over your drawing using ink and erase any unwanted pencil lines.

4 Colour your weapon. The steel has been painted for camouflage. Use soft tones of an appropriate colour.

exocet missile

Originating in France in the 1980s, this missile was designed for attacking warships.

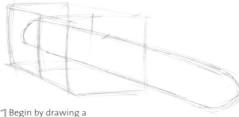

1 Begin by drawing a pencil sketch of the missile. Perspective is key at this stage.

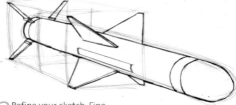

2 Refine your sketch. Fine-tune the body shape of the missile. Draw in the wings mid-body and the fins at the tail end.

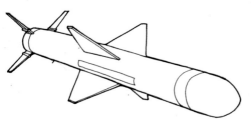

3 Go over your drawing using ink and erase any unwanted pencil lines.

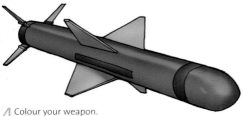

4 Colour your weapon. This example has a polished steel finish. Use bright highlights to show where it catches the light.

GALLERY

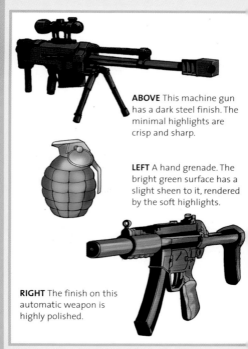

ABOVE This machine gun has a dark steel finish. The minimal highlights are crisp and sharp.

LEFT A hand grenade. The bright green surface has a slight sheen to it, rendered by the soft highlights.

RIGHT The finish on this automatic weapon is highly polished.

RIGHT There is a high contrast between the light and shade areas on this revolver.

LEFT A futuristic-looking weapon in camouflage colours. Highlights are minimal.

BELOW Seen side on, this weapon has a smooth, soft surface and blended highlights.

vehicles

This section takes a look at the kinds of vehicle you are most likely to want to draw and colour for your manga comic strips. With 27 step-by-step projects in total you will find everything here, from bicycles and saloon cars, through passenger jets and helicopters, to armoured personnel carriers and space shuttles.

horse-drawn carriage

You can use this model for a range of different horse-drawn vehicles. Develop your own version, if you like.

1 Using a pencil, draw a very rough outline of your vehicle. Try to get the most basic shape, but with the right proportions.

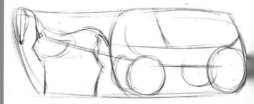

2 Start to draw the vehicle in more detail. Using your outline as a guide, get the positions and proportions of the horse and carriage right.

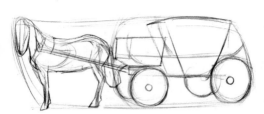

3 Make the horse more three-dimensional. Draw basic shapes for the different carriage parts.

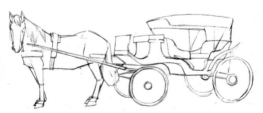

4 Give the horse realistic features – a face, mane and hooves. Work on the carriage, defining hood, chassis and seating.

▶▶

horse-drawn carriage continued

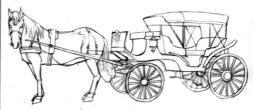

5 Work on the finer details, now. Draw in the horse's bridle, the spokes in the wheels and any decorative elements.

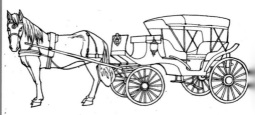

6 Go over your finished artwork using ink and erase visible pencil lines.

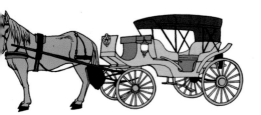

7 Colour your artwork.
Use flat colour first.
Keep the horse a uniform
grey. Use various shades for
the hood, seating and body
of the carriage.

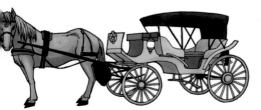

8 Add shadows on the
horse's neck and belly,
and on the underside of
the carriage. Use highlights
to pick out brighter areas.

bicycle

Bicycles are notoriously difficult to draw. The key lies in achieving the right proportions.

1 Using a pencil, draw a very rough outline of the bicycle. Draw the basic shape made by the bike.

2 Work within your outline to sketch the frame of the bicycle and the wheels.

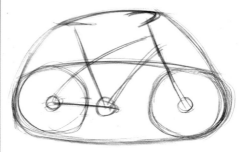

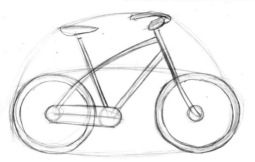

3 Use your sketch to give more definition to the different parts of the bike. Make it three-dimensional.

4 Fine-tune the various parts, giving them more shape – the saddle, handlebars, wheels, pedal.

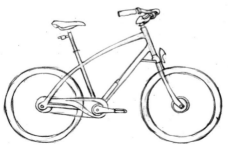

▶▶

bicycle continued

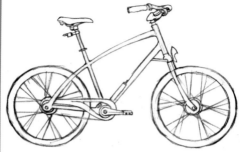

5 Work on the finer details, now. Draw in the spokes in the wheels.

6 Go over your finished artwork using ink and erase visible pencil lines.

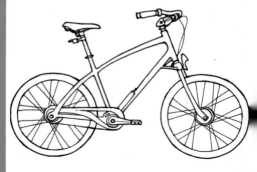

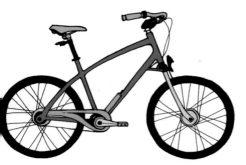

7 Colour your artwork, using flat colour to start with.

8 Add soft highlights to keep the bike looking three-dimensional.

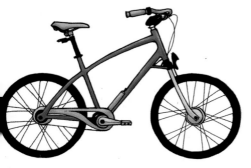

rickshaw

This human-powered mode of transport is commonly associated with the Far East and India.

1 Using a pencil, draw the basic shape made by the rickshaw and, in this case, the man drawing it along.

2 Work within your outline to sketch the frame of the vehicle and the man pulling it.

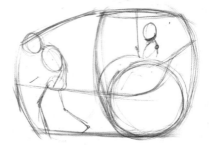

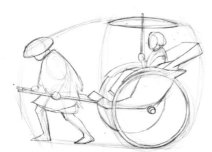

3 Use your sketch to give more definition to the individual elements. Make them three-dimensional.

4 Start to add detail – the texture of the man's coat, the folded-back rickshaw hood.

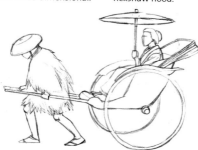

▶▶

rickshaw continued

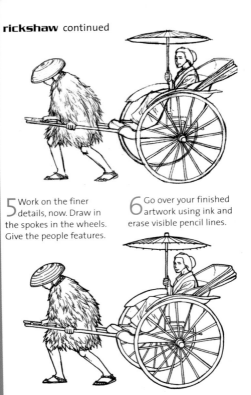

5 Work on the finer details, now. Draw in the spokes in the wheels. Give the people features.

6 Go over your finished artwork using ink and erase visible pencil lines.

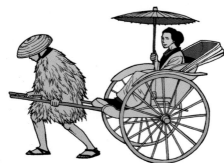

7 Colour your artwork, using simple, flat colours to start with.

8 Add soft shadows to keep the rickshaw looking three-dimensional.

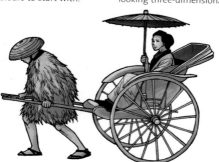

scooter

The principles for drawing a scooter are very similar to those for drawing a bicycle.

1 Using a pencil, draw a very rough outline of the scooter. Draw the basic shape it makes.

2 Work within your outline to sketch the general frame of the scooter and its wheels.

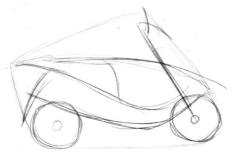

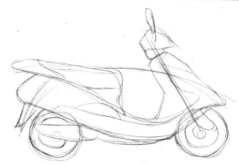

3 Start to make it three-dimensional. Draw each of the scooter's body parts individually.

4 Fine-tune the body parts, giving them more shape – the saddle, handlebars, wing mirror.

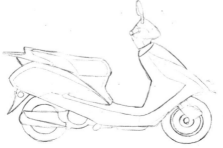

▶▶

scooter continued

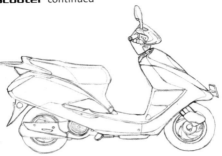

5 Draw in the styling on the body work and the visible engine parts. Work on any additional details.

6 Go over your finished artwork using ink and erase any unwanted pencil lines.

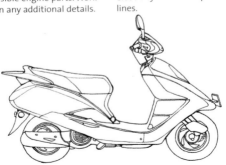

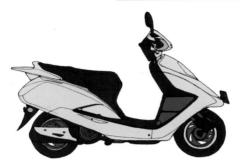

7 Colour your artwork, using flat colour to start with. The body of this scooter has a metal finish.

8 Add highlights for a three-dimensional look. Make these brighter on the metal areas.

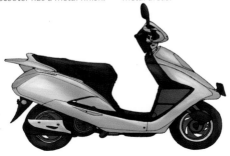

motorbike

This is similar to the illustration for the scooter. The main difference is that more of the engine is visible.

1 Using a pencil, draw a very rough outline of the motorbike. Draw the basic shape it makes.

2 Work within your outline to sketch the general frame of the motorbike and its wheels.

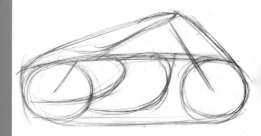

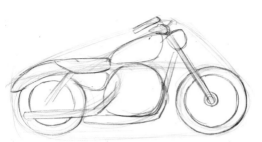

3 Start to make it three-dimensional. Draw each of the motorbike's body parts individually.

4 Fine-tune the body parts, giving them more shape – the saddle, mud guards, engine.

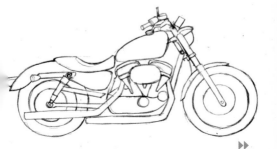

▶▶

motorbike continued

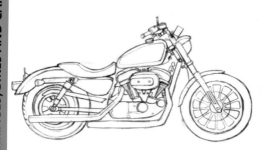

5 Draw the engine in much more detail now. Add the spokes in the wheels.

6 Go over your finished artwork using ink and erase any unwanted pencil lines.

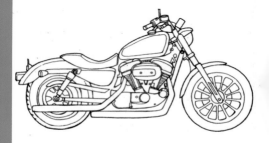

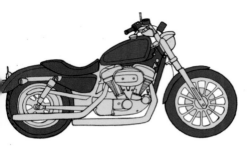

7 Colour your artwork, using flat colour to start with. The engine has a polished metal finish.

8 Add highlights to capture the gleam of the painted metal body work and the engine parts.

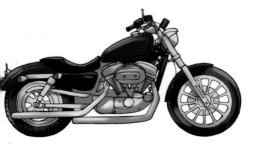

small saloon car

This car is seen from the three-quarter view. The same principles can be applied to any model.

1 Using a pencil, draw a very rough outline of the car. Think carefully about perspective at this stage.

2 Work on your outline to sketch the body of the car. Draw in the visible wheels.

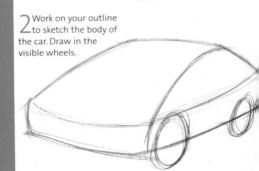

3 Start to make it three-dimensional. Draw in the bonnet and the windscreen.

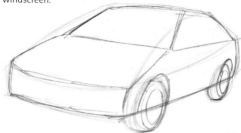

4 Add individual body parts – the headlights, side windows, front bumper, and so on.

▶▶

small saloon car continued

5 Draw in the finer details: the badge on the grill, the wing mirrors, the wheels.

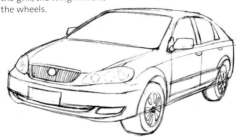

6 Go over your finished artwork using ink and erase any unwanted pencil lines.

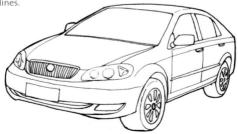

7 Colour your artwork, using flat colour to start with. This example has a silver finish.

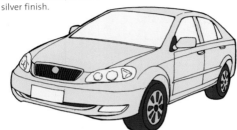

8 Add highlights to capture the gleam of the car and the reflective nature of its windows.

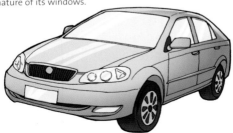

supercar

The design for this sporty supercar is based on that of a Lamborghini, but you can use any car you like.

1 Using a pencil, draw a rough outline of the car. Think about perspective.

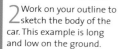

2 Work on your outline to sketch the body of the car. This example is long and low on the ground.

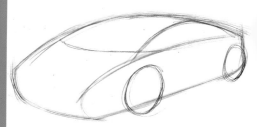

3 Start to make it three-dimensional. Give shape to the front of the car and the sloping rear. Draw in the tyres.

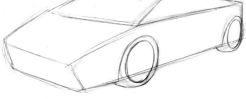

4 Add individual body parts – the headlights, side windows, rear spoiler, and so on.

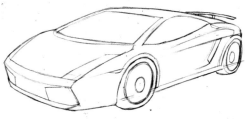

supercar continued

5 Draw in the finer details: the visible wing mirrors, the wheels, the sculpted doors.

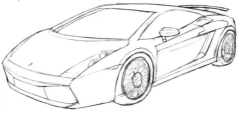

6 Go over your finished artwork using ink and erase any unwanted pencil lines.

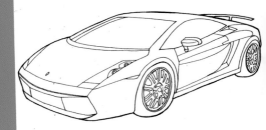

7 Colour your artwork, using flat colour to start with. Use a bright colour to emphasise the sporty nature of the vehicle.

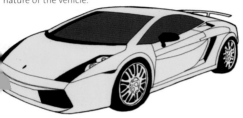

8 Add highlights to capture the gleam of the body work and the reflections in the dark, tinted windows.

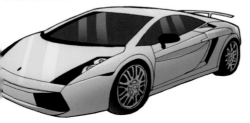

off-roader

Off-roaders are hard-working, practical vehicles – ideal for scenes with open terrain.

1 Using a pencil, draw the rough shape of the vehicle. Think about perspective.

2 Work on your outline to sketch the body of the vehicle. Most off-roaders are square and boxy. Draw in the wheels.

3 Start to make it three-dimensional. Give shape to the bonnet of the vehicle and add the flat windscreen.

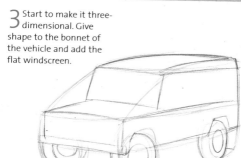

4 Add individual body parts – the registration plate, wing mirrors, side windows, wheel arches and mud flaps.

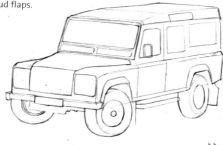

▶▶

off-roader continued

5 Draw in the finer details: the headlights, radiator grill, door handles and windscreen wipers.

6 Go over your finished artwork using ink and erase any unwanted pencil lines.

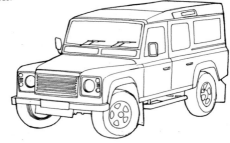

7 Colour your artwork, using an appropriate colour. This example is a blue-grey. Use flat colour to start.

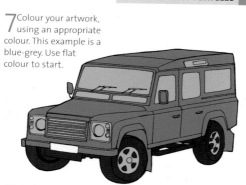

8 Work in some lighter tones for highlights, and to capture the reflective nature of the vehicle's windows.

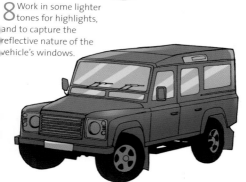

people carrier

This is a typical, modern-day people carrier. You can base it on any model you like.

1 Using a pencil, draw a rough outline of the car. Think carefully about perspective.

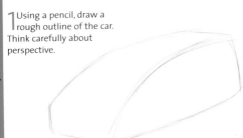

2 Work on your outline to sketch the body of the vehicle. People carriers are proportionally longer than the average car. Draw in the wheels.

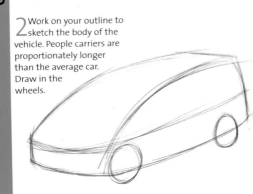

3 Give shape to vehicle, to make it look more three-dimensional.

4 Work on the details – the shape of the headlights, the windows, the wheel arches.

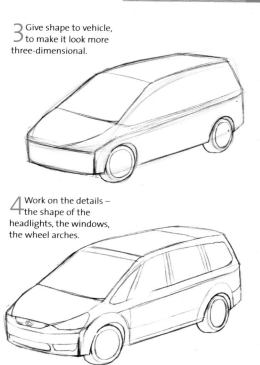

▶▶

people carrier continued

5 Draw in the finer details: the wheels, wing mirror, door handles and sun roof.

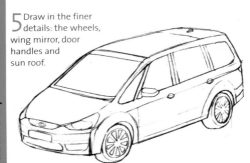

6 Go over your finished artwork using ink and erase any unwanted pencil lines.

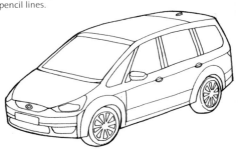

7 Colour your artwork, using an appropriate colour. Keep the colours flat to start.

8 Use subtle shading and highlights to build up the metallic finish of the paintwork, and to capture the transparency of the windows.

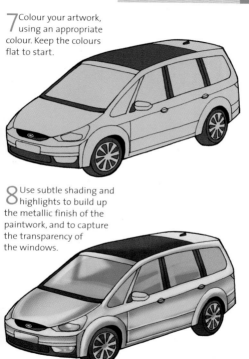

ambulance

You can use any type of ambulance for inspiration.

1 Using a pencil, draw a rough outline of the vehicle. Think carefully about perspective.

2 Work on your outline to sketch the body of the vehicle. This model is a van with a pick-up-style cab. Draw in the wheels.

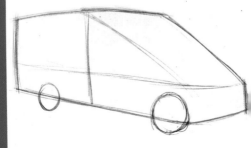

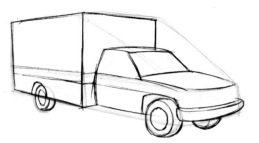

3 Make your sketch look three-dimensional. Give the wheels some tyres, draw in the bonnet and windscreen.

4 Work on the details – the shape at the front, the position of the wing mirrors, the wheel arches.

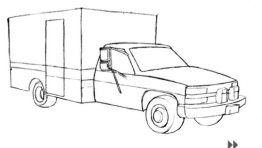

▶▶

ambulance continued

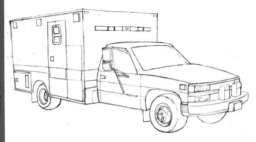

5 Draw in the finer details: the wheels, additional windows and ventilation panels.

6 Go over your finished artwork using ink and erase all of the pencil lines.

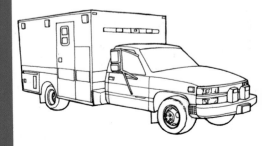

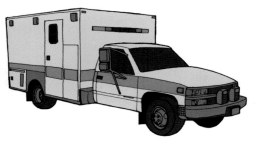

7 Colour your artwork, using an appropriate colour. Keep the colours flat to start.

8 Ambulances are almost always white. Use soft tones to create the shadow areas. Use highlights to show the reflective glass.

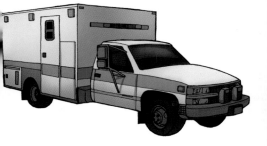

bus

This is a large-scale American bus. Many European examples are modelled on this type.

1 Using a pencil, draw a rough outline of the vehicle. Think carefully about perspective.

2 Work on your outline to sketch the body of the vehicle. This model is almost a perfect rectangle. Draw in the wheels.

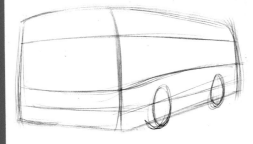

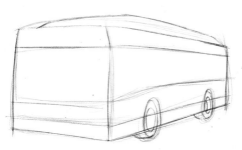

3 Make your sketch look three-dimensional. Give shape to the roof of the bus and draw in some wheels. Mark the windows.

4 Work on the details – the shape at the front of the bus and the pillars between the windows.

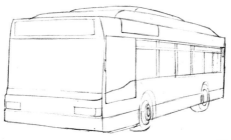

▶▶

bus continued

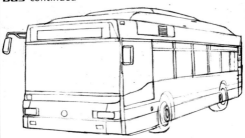

5 Draw in the finer details: ventilation panels, wing mirrors, headlights and wheels.

6 Go over your finished artwork using ink and erase all of the pencil lines.

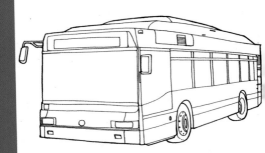

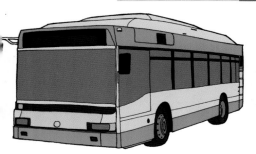

7 Colour your artwork, using an appropriate colour. Keep the colours flat to start.

8 Lighten up the darker tones in places, to keep the image looking three-dimensional. Add reflective highlights on the windows.

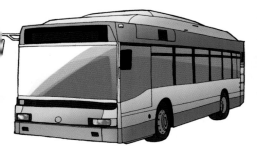

fire engine

There are various models of fire engines to take inspiration from. Or use an old-fashioned version.

1 Using a pencil, draw a rough outline of the vehicle. Think carefully about perspective.

2 Work on your outline to sketch the body of the vehicle. This model is rectangular. Add wheels.

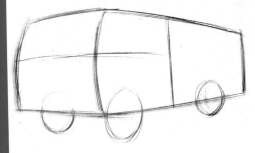

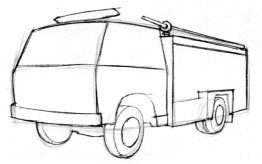

3 Make your sketch look three-dimensional. Give shape to the cab area and draw in some wheels.

4 Work on the details – the front of the cab and the windows. Draw in wing mirrors and lights.

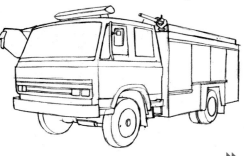

▶▶

fire engine continued

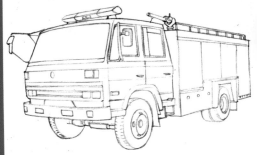

5 Draw in the finer details: the rail at the top, the tread on the tyres, door handles and so on.

6 Go over your finished artwork using ink and erase all of the pencil lines.

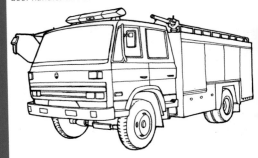

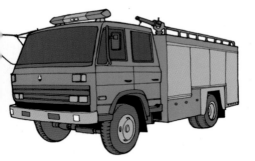

7 Colour your artwork, using an appropriate colour – in this case, red. Keep the colours flat.

8 Use subtle shading to make the engine look three-dimensional. Add reflective highlights on the windows.

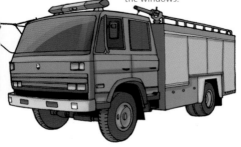

truck

This is a heavy-duty truck, built for taking on those long, cross-country distances.

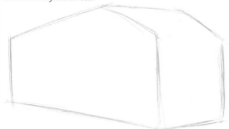

1 Using a pencil, draw a rough outline of the vehicle. Think carefully about perspective.

2 Work on your outline to sketch the body of the vehicle. Note that the cab is lower than the trailer.

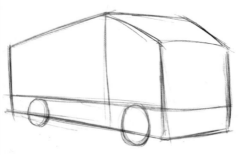

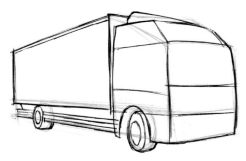

3 Make your sketch look three-dimensional. Give shape to the cab area and draw in some wheels.

4 Work on the details – the front of the cab and the windows. Draw in the trailer bed.

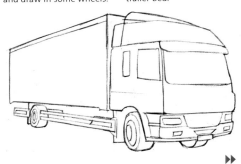

▶▶

truck continued

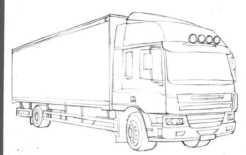

5 Draw in the finer details: the wing mirrors, light clusters, radiator grill and wheels.

6 Go over your finished artwork using ink and erase all of the pencil lines.

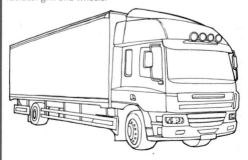

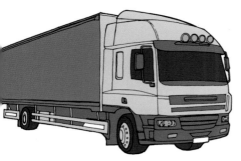

7 Colour your artwork, using an appropriate colour – in this case, grey. Keep the colours flat.

8 Use subtle shading to make the engine look three-dimensional. Add highlights on the windows.

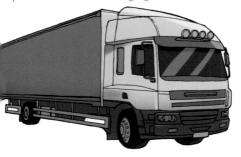

goods train

Goods trains tend to be heavier-looking and less sleek than passenger trains.

1 Using a pencil, draw a rough outline of the train. Think about proportions and perspective.

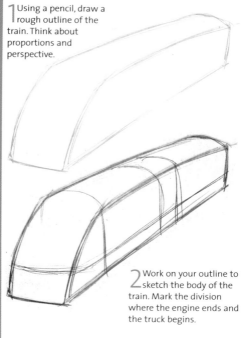

2 Work on your outline to sketch the body of the train. Mark the division where the engine ends and the truck begins.

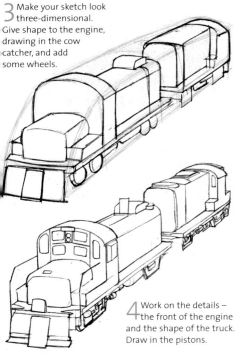

3 Make your sketch look three-dimensional. Give shape to the engine, drawing in the cow catcher, and add some wheels.

4 Work on the details – the front of the engine and the shape of the truck. Draw in the pistons.

▶▶

goods train continued

5 Draw in the finer details: the guard rails, the little windows. It might help to have a picture for reference.

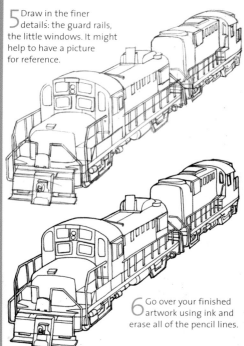

6 Go over your finished artwork using ink and erase all of the pencil lines.

7 Colour your artwork, using an appropriate colour. Keep the colours flat at this stage.

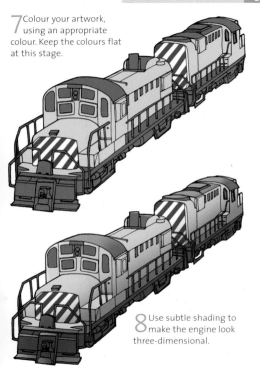

8 Use subtle shading to make the engine look three-dimensional.

bullet train

This is a state-of-the-art passenger train, based on the Japanese model.

1 Using a pencil, draw a rough outline of the train. This example is long and sleek, with perfect aerodynamics.

2 Work on your outline to sketch the body of the train. Mark the divisions where the engine ends and each carriage begins. Draw in the front window.

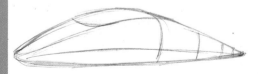

3 Make your sketch look three-dimensional. Give shape to the engine section of the train.

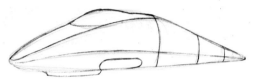

4 Work on the details – the bubble window, the carriage windows, the nose of the engine.

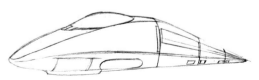

▶▶

bullet train continued

5 Draw in the finer details: the access panels for the engine and the windows of the carriages.

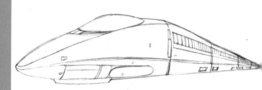

6 Go over your finished artwork using ink and erase all of the pencil lines.

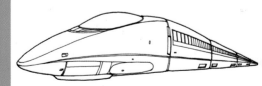

7 Colour your artwork, using appropriate colours. Keep the colours flat at this stage.

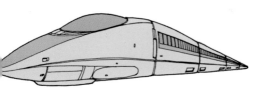

8 This is a sleek, ultra-modern machine. Use highlights to give the train a glossy, metallic finish.

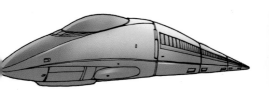

hot-air balloon

A hot-air balloon is relatively easy to draw. In this example, it is seen from below.

1 Using a pencil, draw a rough outline of the balloon. Include the basket in capturing its general shape.

2 Work on your outline to sketch the body of the balloon. Use a series of ellipses to get the perspective right.

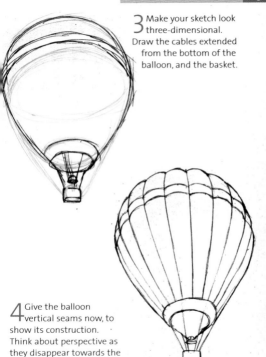

3 Make your sketch look three-dimensional. Draw the cables extended from the bottom of the balloon, and the basket.

4 Give the balloon vertical seams now, to show its construction. Think about perspective as they disappear towards the rear of the balloon.

▶▶

hot-air balloon continued

5 Draw in the horizontal seams now, again thinking about perspective. Draw in the texture of the basket.

6 Go over your finished artwork using ink and erase all of the pencil lines.

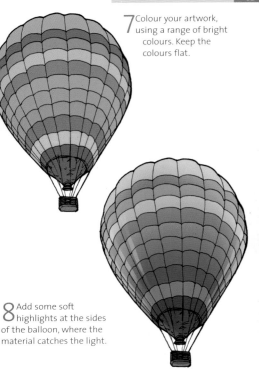

7 Colour your artwork, using a range of bright colours. Keep the colours flat.

8 Add some soft highlights at the sides of the balloon, where the material catches the light.

passenger jet

You can use the following model to draw an aeroplane of any size, from small-scale two-seater to Jumbo jet.

1 Using a pencil, draw a rough outline of the aircraft. Just draw the fuselage and the sweep of the wings at this stage.

2 Work on your outline to sketch the body in more detail. Mark the positions of the engines and the tail fin.

3 Make your sketch look three-dimensional. Draw the tail and wings in more detail, bearing in mind perspective.

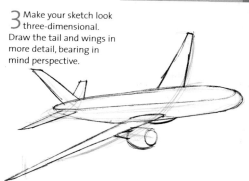

4 Refine your shapes. Draw the engines in greater detail and give the wings flaps.

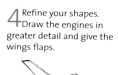

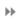

passenger jet continued

5 Draw in the windows and give the plane some logos.

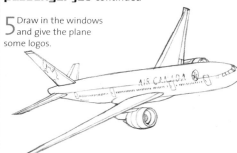

6 Go over your finished artwork using ink and erase all of the pencil lines.

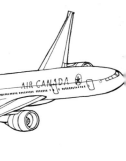

7 Colour your artwork, keeping the colours flat at this stage.

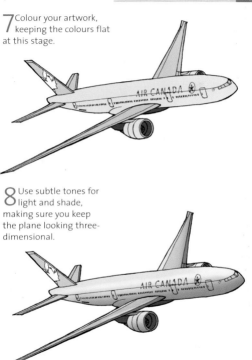

8 Use subtle tones for light and shade, making sure you keep the plane looking three-dimensional.

F-16 fighting falcon

You can use the passenger jet as a basic model for this project. Fighter planes are smaller and leaner.

1 Using a pencil, draw a rough outline of the aircraft.

2 Work on your outline, marking the positions of the engines and the tail fin.

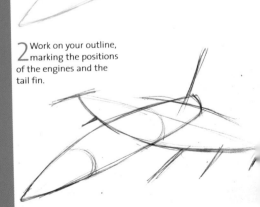

3 Draw the tail and wings in more detail, bearing in mind perspective.

4 Refine the shape of your aircraft. Draw the missiles in greater detail.

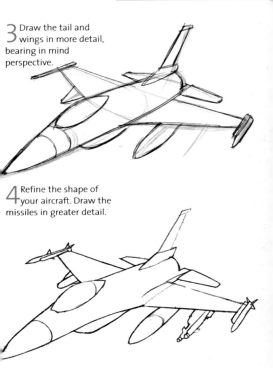

▶▶

F-16 fighting falcon continued

5 Fine-tune the drawing –
bring the nose of the
plane to a point – and any
surface details.

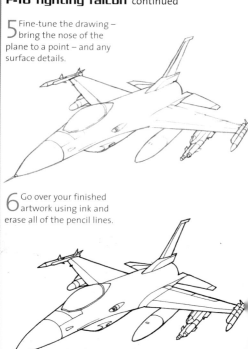

6 Go over your finished
artwork using ink and
erase all of the pencil lines.

7 Colour your artwork using military shades. Keep the colours flat.

8 Keep the aircraft looking three-dimensional, using subtle tones for light and shadow.

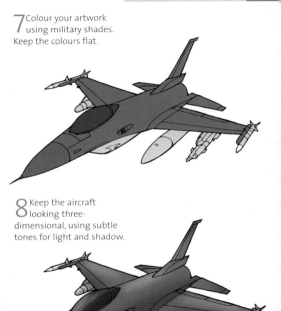

sikorsky 5-76 helicopter

There are many helicopters to choose from when it comes to finding a model. The principles for drawing remain the same.

1 Using a pencil, draw a rough outline of the helicopter. Try to capture the shape made by the aircraft as a whole.

2 Work on your outline to sketch the body in more detail. Give more shape to the tail and draw in the rotors.

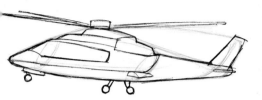

3 Make your sketch look three-dimensional. Define the shape of the helicopter more clearly. Draw in the landing gear.

4 Refine your shapes. Draw the rotors, windows and wheels in greater detail.

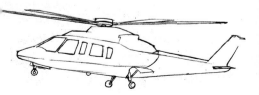

▶▶

sikorsky S-76 helicopter continued

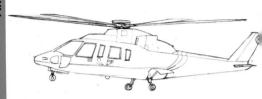

5 Finish your drawing, giving the windows frames and adding any surface markings.

6 Go over your finished artwork using ink and erase all of the pencil lines.

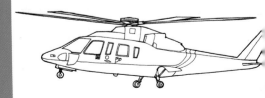

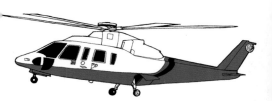

7 Colour your artwork, keeping the colours flat at this stage. This helicopter has a white and red colour scheme.

8 Use subtle tones for shaded areas and sharp highlights where the painted metal catches the light.

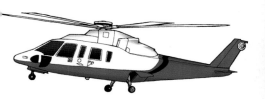

challenger tank

You can use any model as a basis for drawing a tank.
Or invent a tank of your own.

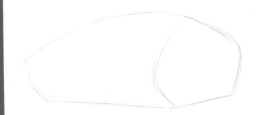

1 Using a pencil, draw a
very rough outline of
your vehicle. Try to capture
its most basic shape.

2 Work on your outline
to sketch the body in
more detail. Mark the
position of the gun.

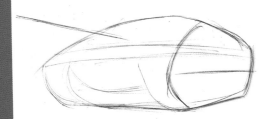

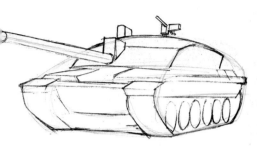

3 Draw the tank in much greater detail. Give shape to the body, the gun and the caterpillar tracks.

4 Refine your shapes. Draw the individual armour plates and add detail to the wheels.

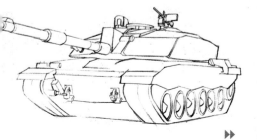

▶▶

challenger tank continued

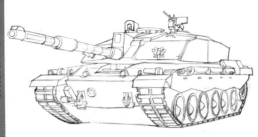

5 Finish your drawing, adding all the remaining surface details – draw the caterpillar tread.

6 Go over your finished artwork using ink and erase all of the pencil lines.

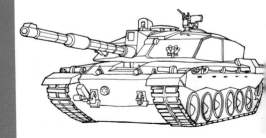

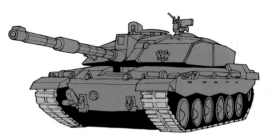

7 Colour your artwork, using appropriate colours. Keep the colours flat at this stage.

8 This tank has camouflage paint. Use soft tones and keep highlights to a minimum.

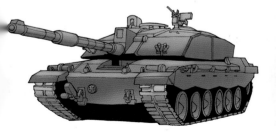

armoured personnel carrier

Like the tank on the previous pages, you can use any personnel carrier as inspiration for this project.

1 Using a pencil, draw a very rough outline of your vehicle. Try to capture its most basic shape.

2 Work on your outline. The vehicle is flat-sided and rectangular – keep your lines straight.

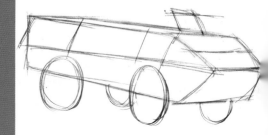

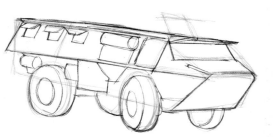

3 Make your sketch look three-dimensional. Give shape to the front of the vehicle and draw in the wheels.

4 Refine your shapes. Draw in the gun mounted towards the front of the carrier.

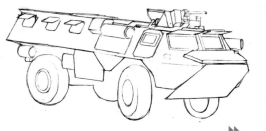

▶▶

armoured personnel carrier continued

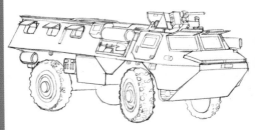

5 Finish your drawing, adding any surface details, such as the tread on the tyres.

6 Go over your finished artwork using ink and erase all of the pencil lines.

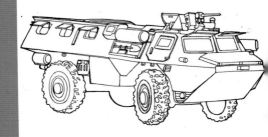

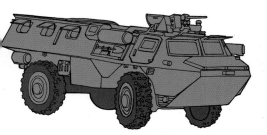

7 Colour your artwork, using an appropriate colour. Keep the colour flat.

8 Use subtle tones for light and shade. Add highlights where the windows catch the light.

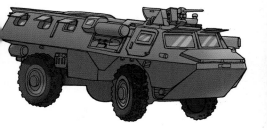

man-o-war

The man-o-war is a fighting ship dating back to 17th- and 18th-century Europe.

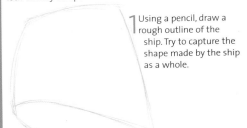

1 Using a pencil, draw a rough outline of the ship. Try to capture the shape made by the ship as a whole.

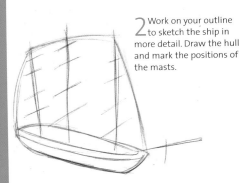

2 Work on your outline to sketch the ship in more detail. Draw the hull and mark the positions of the masts.

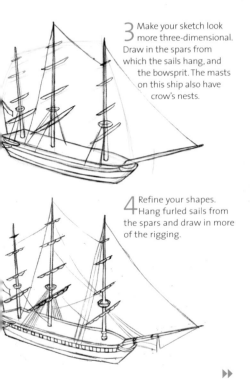

3 Make your sketch look more three-dimensional. Draw in the spars from which the sails hang, and the bowsprit. The masts on this ship also have crow's nests.

4 Refine your shapes. Hang furled sails from the spars and draw in more of the rigging.

▶▶

man-o-war continued

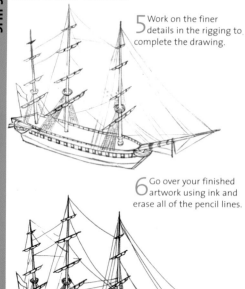

5 Work on the finer details in the rigging to complete the drawing.

6 Go over your finished artwork using ink and erase all of the pencil lines.

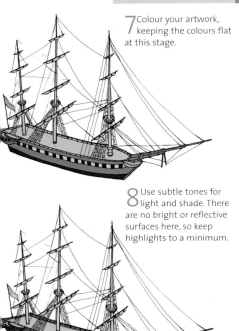

7 Colour your artwork, keeping the colours flat at this stage.

8 Use subtle tones for light and shade. There are no bright or reflective surfaces here, so keep highlights to a minimum.

passenger liner

This is a large-scale cruise ship – the sort that might embark on a long-distance journey across the Atlantic.

1 Using a pencil, draw a rough outline of the ship. Just draw its basic shape at this stage.

2 Work on your outline to sketch the body of the ship in greater detail. Think about perspective.

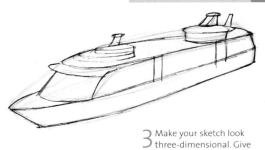

3 Make your sketch look three-dimensional. Give shape to the bow and mark out the upper decks.

4 Mark out the rough layout of the windows that run the ship's length and draw in the lifeboats. Consider scale carefully.

▶▶

passenger liner continued

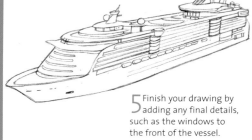

5 Finish your drawing by adding any final details, such as the windows to the front of the vessel.

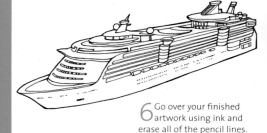

6 Go over your finished artwork using ink and erase all of the pencil lines.

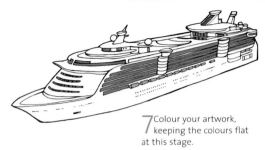

7 Colour your artwork, keeping the colours flat at this stage.

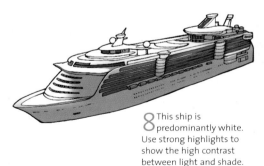

8 This ship is predominantly white. Use strong highlights to show the high contrast between light and shade.

battlecruiser

Used mostly during the first half of the 20th century, the battlecrusier was a heavily armed warship.

1 Using a pencil, draw a rough outline of the ship. Try to capture the shape made by the ship as a whole.

2 Work on your outline to sketch the body in more detail. Mark the positions of the masts.

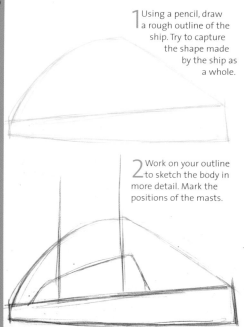

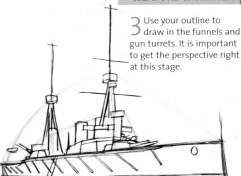

3 Use your outline to draw in the funnels and gun turrets. It is important to get the perspective right at this stage.

4 Refine your outline here and there to give the ship its three-dimensional appearance.

▶▶

battlecruiser continued

5 Work on the finer
details, now – the
portholes in the hull of
the ship, the ladder
leading up to the deck,
the anchor chain
at the bow.

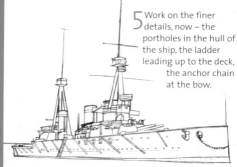

6 Go over your
finished artwork
using ink and erase all
of the pencil lines.

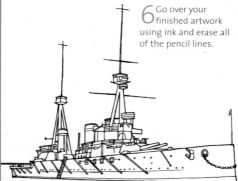

7 Colour your artwork using a battleship grey. Keep the colour flat.

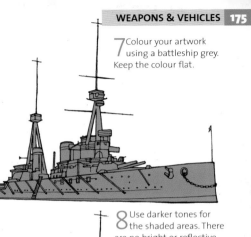

8 Use darker tones for the shaded areas. There are no bright or reflective surfaces here, so keep highlights to a minimum.

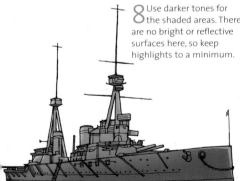

aircraft carrier

The most distinctive feature of the aircraft carrier is its wide, flat deck for take-off and landing.

1 Using a pencil, draw a rough outline of the aircraft. Just draw its basic shape at this stage.

2 Work on your outline to sketch the body in more detail. Think about getting the proportions and perspective right.

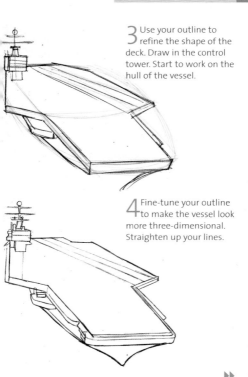

3 Use your outline to refine the shape of the deck. Draw in the control tower. Start to work on the hull of the vessel.

4 Fine-tune your outline to make the vessel look more three-dimensional. Straighten up your lines.

▶▶

aircraft carrier continued

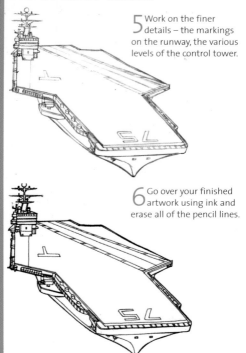

5 Work on the finer details – the markings on the runway, the various levels of the control tower.

6 Go over your finished artwork using ink and erase all of the pencil lines.

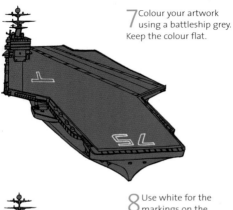

7 Colour your artwork using a battleship grey. Keep the colour flat.

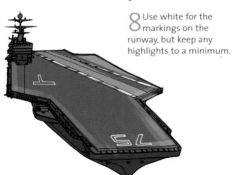

8 Use white for the markings on the runway, but keep any highlights to a minimum.

submarine

Used to great effect during the Second World War, there are many submarine models to choose from for inspiration.

1 Using a pencil, draw a rough outline of the submarine. Try to capture the shape made by the vessel as a whole.

2 Work on your outline to sketch the body of the submarine. Use a series of ellipses to get the perspective right.

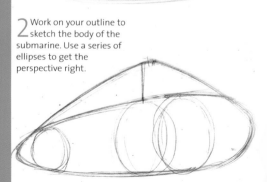

3 Refine the shape of the submarine to make it look three-dimensional. Draw in the fin on top and the propeller to the rear.

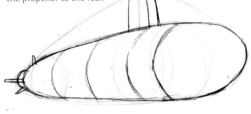

4 Fine-tune your outline and mark the positions of the ballast tanks on the underbelly of the submarine.

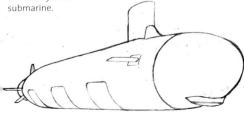

▶▶

submarine continued

5 Work on the surface details. Mark out the individual plates of armour and draw in the ballast tank doors.

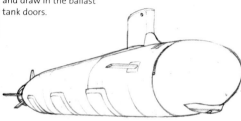

6 Go over your finished artwork using ink and erase all of the pencil lines.

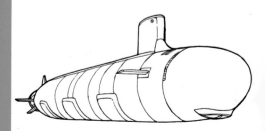

7 Colour your artwork using a battleship grey. Keep the colour flat.

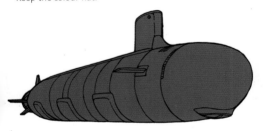

8 Use highlights to help capture the smooth, round surfaces and the raised edges of the ballast tank doors.

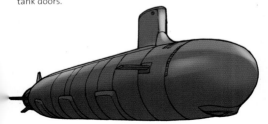

space shuttle

This space shuttle takes inspiration from the Challenger models designed in the United States.

1 Using a pencil, draw a rough outline of the shuttle. Just draw the fuselage and the sweep of the wings at this stage.

2 Work on your outline to sketch the body of the space shuttle. Use ellipses to help with perspective.

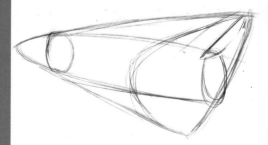

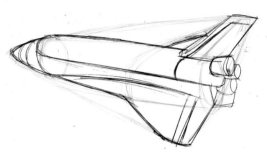

3 Refine the shape of the shuttle to make it look three-dimensional. Draw in the wings and tail fin to the rear.

4 Fine-tune your outline and mark the position of the window to the front. Give more shape to the rockets at the rear.

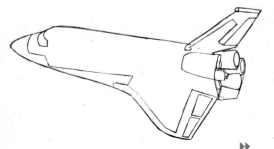

▶▶

space shuttle continued

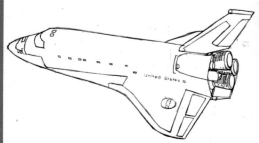

5 Work on the finer details, now – the windows to the front and side, and the shading on the rockets.

6 Go over your finished artwork using ink and erase all of the pencil lines.

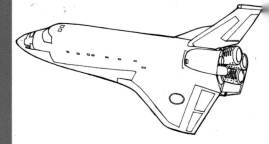

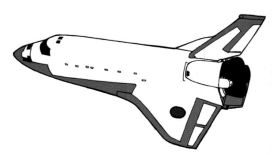

7 Colour your artwork using a limited palette. Keep the colour flat.

8 This shuttle is mostly white. Use dark shadows to show the high contrast between light and shade.

GALLERY

LEFT A Jeep-type military vehicle, with a camouflage paint finish.

RIGHT A brightly-coloured airship, complete with passenger basket.

LEFT An old-fashioned looking horse and carriage, driven by an aged coachman.

RIGHT A modern four-wheel-drive farm tractor with heavy-tread tyres.

LEFT A modern-day, high-powered motorcycle.

RIGHT A futuristic-looking spaceship with rockets on full blast.

index

▶▶

index